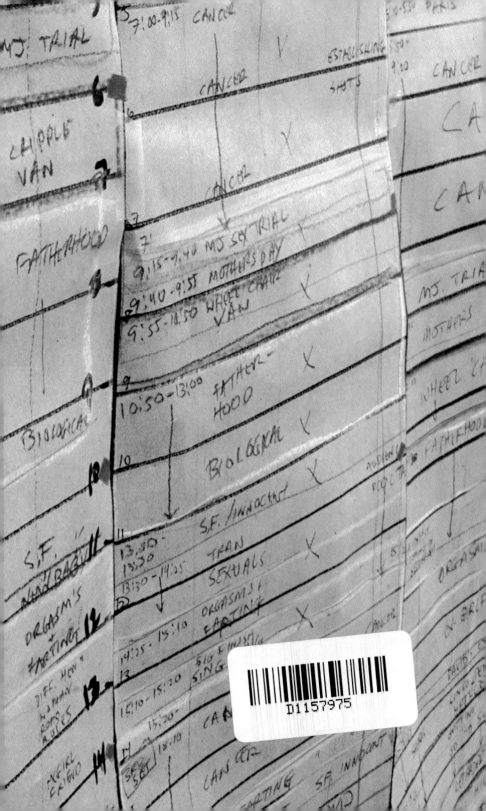

Edgar Arceneaux would like to thank David Alan Grier, Anthony Elms, Sascha Robinett, Zora Emi Arceneaux, Charles Gaines, Susanne Vielmetter, Joanna Kamm, Stephan Adamski, Merc and Ron, Cheryl Lynn Bruce, Kerry James Marshall, Sam Han, Rodney McMillian, Douglas Fogle, Linda Pace, and the staff at Artpace: Kathryn Kanjo, Kimberly Aubuchon, Mary E. Cantú, Kate Green, David Guerrero, Mary Heathcott, Jay Lopez, Connie McAllister, Kelly O'Connor, Mario Perez, Riley Robinson, Trisha Tanner, Libby D. Tilley, and Ray Ybarra. Thanks to the student production assistants on the UIC shoot, Gallery 400's shoot coordinators and its programming and installation crew. Thank you to the bands, Pit Er Pat, Dark Fog, and the Pringles. Thanks for equipment go to Helix Camera and Video, Grand Stage-Chicago, and Essanay Studio and Lighting Company. And special thanks are due to all those who attended the performances and brought the comedy to life.

Special thanks to Lorelei Stewart. Valleys and mountains, but all worth it. Thank you, Edgar

## EDGAR ARCENEAUX: THE ALCHEMY OF COMEDY...STUPID

(ISBN 0-945323-11-5)
(ISBN-13 978-0-945323-11-2)

## PUBLISHED BY

WhiteWalls, Inc., a not-for-profit corporation
P.O. Box 8204, Chicago, Illinois 60680

Gallery 400, the College of Architecture and the Arts, University of Illinois at Chicago
400 South Peoria (MC 034), Chicago, Illinois 60607

WhiteWalls books are distributed by the University of Chicago Press

## WHITEWALLS EDITOR

Anthony Elms

## EDGAR ARCENEAUX: THE ALCHEMY OF COMEDY...STUPID

was commissioned and produced by Gallery 400, the College of Architecture and the Arts, University of Illinois at Chicago. Major funding for this project was provided by a 2005 Joyce Award from the Chicago-based Joyce Foundation. Additional support was provided by contributions from the Pasadena Arts and Culture Commission and the City of Pasadena Cultural Affairs Division and Artpace San Antonio.

This catalog is generously supported by Sara Szold.

Gallery 400 is supported by the Daryl Gerber Stokols and Jeff Stokols Voices Series Fund; a grant from the Illinois Arts Council, a state agency; and the College of Architecture and the Arts, University of Illinois at Chicago.

WhiteWalls Board: Gary Cannone, Steve Harp, Karen Lebergott, Adelheid Mers, Joel Score and Sarah Peters

For 2006-07, WhiteWalls publications are dedicated to Michael Piazza and his tireless enthusiasm.

Contributions and gifts to WhiteWalls, Inc., are tax-deductible to the extent allowed by law. This publication is supported in part by grants from the Illinois Arts Council, a state agency; by a CityArts grant from the City of Chicago Department of Cultural Affairs; and by our friends and subscribers. WhiteWalls, Inc., is a member of the Illinois Arts Alliance and the National Association of Artists Organizations.

## DESIGN

Department of Graphic Sciences

Printed in China

EDGAR ARCENEAUX
# THE ALCHEMY OF COMEDY...STUPID
STARRING DAVID ALAN GRIER

# TABLE OF CONTENTS

THE EXISTENCE OF
MULTIPLE REALITIES

↓

THE SPACE BETWEEN MOMENTS
(A NEGATIVE TIME)
THAT PARADOXICALLY PRODUCES
OBJECTS THAT ~~ARE~~ FAIL
TO SUSTAIN THE IDEOLOGY
OF THEIR MOMENT

↓

THE UNREPRESENTABLE PRESENT
IN THE PRESENTATION ITSELF.

↓

DENY GOOD FORM & TASTE

↓

SEARCH FOR NEW PRESENTATIONS
BUT NOT TO ENJOY THEM BUT TO
IMPART A STRONGER PRESENCE
OF THE UNREPRESENTABLE

(WAITING FOR
RESOLVE IN THE
NEXT CLIP)

# FOREWORD
## EDGAR ARCENEAUX IN CHICAGO

Mining the foundations of intellectual monuments such as the Great Library at Alexandria, Galileo's astronomy, or the more historically adjacent popular culture of Hollywood, Edgar Arceneaux's fecund permutations appear sui generis. The ideas that he synthesizes in his installations are only glancingly similar and become related in the never ending flights of his artistic practice. For his project at Gallery 400 in Chicago on the campus of the University of Illinois, Arceneaux proved to be dramatically fluent and mesmerizing. *The Alchemy of Comedy...Stupid* fused all of Arceneaux's usual formal strategies and media: drawing, film and video and emphasized the backstage work and process of conceptualization, rehearsal and performance. Allegories of the cosmos, the universe and the classic idea of comedy can never be exhausted, yet Arceneaux's ambition is such that he collects enormous evidence and research to inform his rich orchestrations. Thematizing the acquisition of knowledge as key, he literally crafted new knowledge in Gallery 400, critically examined his own artistic agency and gave the spotlight to the famous comedian David Alan Grier. A performer with the magnetism of stardom became the surrogate for the artist; a stand-up performance was the centerpiece of this expansive and unsettling work of social inquiry into the politics of cultural taboos.

In multiple locations, on campus, at a bar and in a student theater, Arceneaux directed Grier as he performed and perfected his monologue over and over again. If the artists/actors tired of this excess, their craftsmanlike demeanor revealed little exhaustion. But the live audiences including students, staff and faculty who were obliged to respond became sensitized to the transformative power of language. The repetition of unkind jokes whose targets included the crippled, gay and elderly had the audience coached by the artists in tears...and in laughter.

Given the exceptional support of the Joyce Foundation's program to reinforce creativity and commission work from artists of color, Arceneaux displaced his aesthetic capital to cast a star as his subject and challenge all the post-modern pieties of political correctness rampant in the academy. With aesthetic subtlety, he pushed these

messages right back in our faces on the monitors, reiterated in the enormous black and white charcoal drawing of singed wood in a wheelchair, with its evocation of Richard Pryor. We are very fortunate to have had Edgar on campus and thank him for this remarkable project.

A centerpiece of the College of Architecture and the Arts, Gallery 400 was established in 1983 and plays an important role in the overlapping cultural communities of Chicago and the nation. I am very grateful to Ellen Alberding, Sidney Sidwell and Michelle Boone of the Joyce Foundation for launching this large-scale work on a campus of a public university, educating and expanding the audiences for contemporary art. Trusting the guidance of Lorelei Stewart, Gallery 400 director and curator of the exhibition, the Joyce Foundation opened doors for the artist and our diverse student body, the talented college student production crew, and high school students from the Alternative Schools Network who were given the opportunity to participate with a young artist behind the scenes as he developed his presentation. Both Edgar Arceneaux and Lorelei Stewart were model partners and mentors in this experimental, expansive production, as were actress Cheryl Lynn Bruce, director of photography Ron Clark, producer Merc Arceneaux Jr. and UIC assistant professor Jennifer Reeder. Anthony Elms, Gallery 400 assistant director, has been central to the editorial vision and publication of this catalog. Finally audience members in the rehearsals became self reflective, shifting their positions so that in the final piece they were able to look over the shoulder of Grier and watch themselves as audience in video footage that recorded their response to his monologues. Sharing the stage with partners exemplifies the College's mission of exchange and accessibility, and just as *The Alchemy of Comedy...Stupid* works to transform our understanding of others, so too does the generosity of Sara Szold.

We are grateful for Sara Szold's early insightful recognition of Edgar Arceneaux. Her commitment to contemporary artists and to their education has made this significant catalog available for additional audiences who will also appreciate the lessons gleaned from the artistic translation of alchemical possibilities at UIC's Gallery 400.

Judith Russi Kirshner, Dean

College of Architecture and the Arts
University of Illinois at Chicago

(a) BLUE

6 VIOLET

8

3

ORANGE

YELLOW

DAVID
X

Green

1st
time
switch

GOLDEN WHITE
5 BLUE GREEN

LIGHT YELLOW
1 R J

RED
2

every 2 minutes
go clockwise

Orange 1st take

start on
violet

1 yellow
2 red
3 deep green
5 Blue/Green
6 Purple/violet
7. red
6 Orange
9 Blue

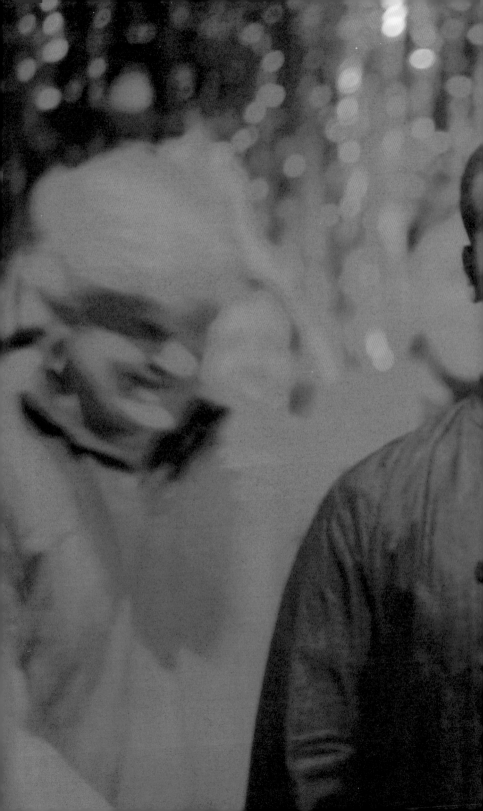

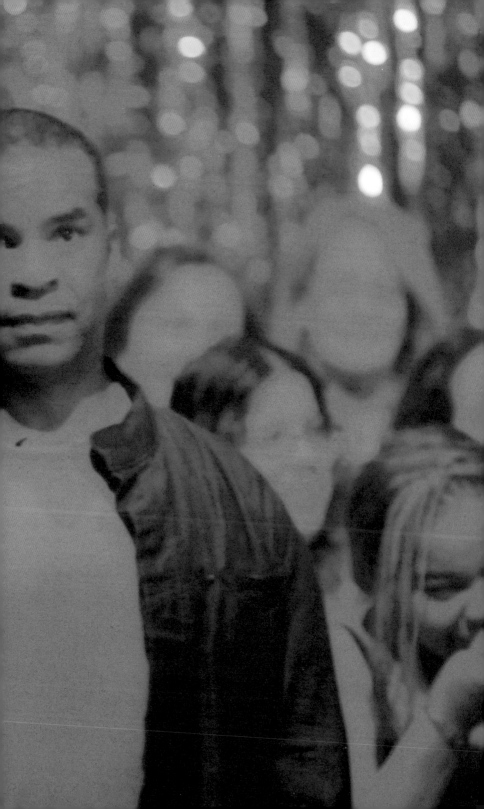

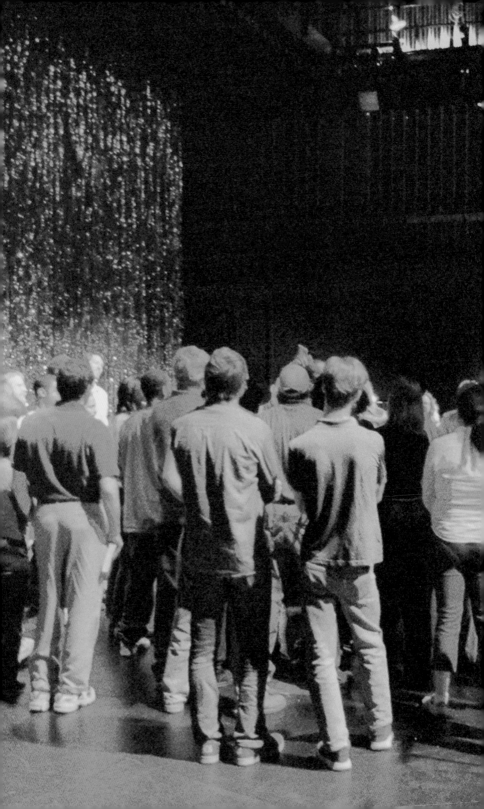

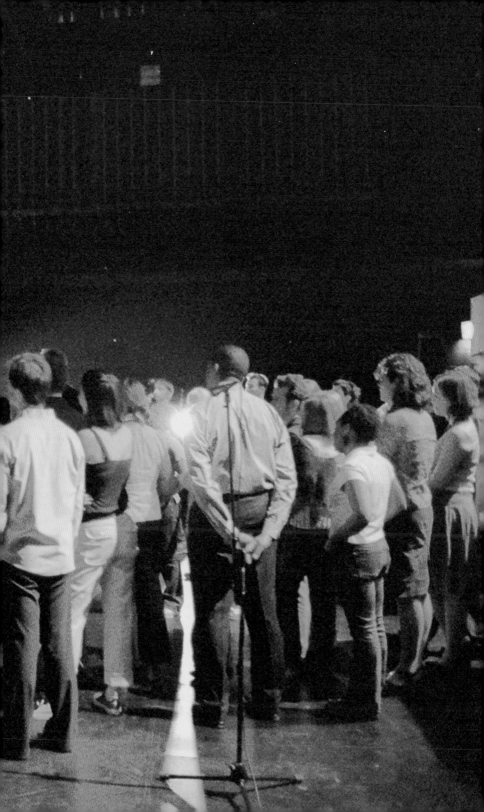

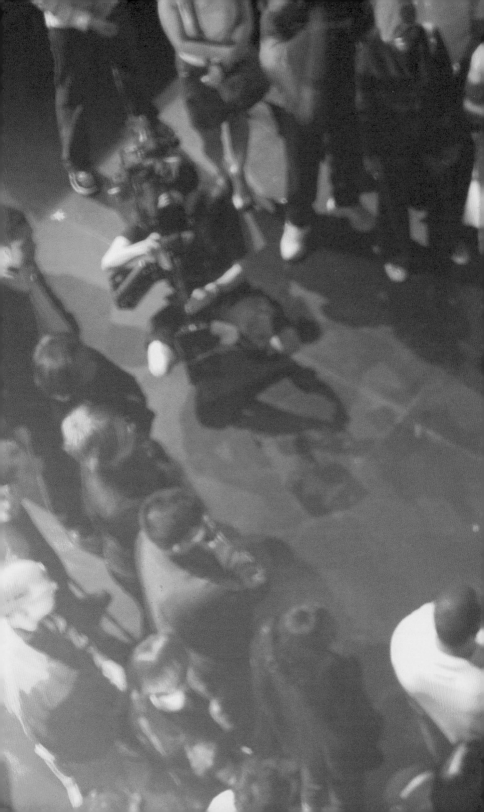

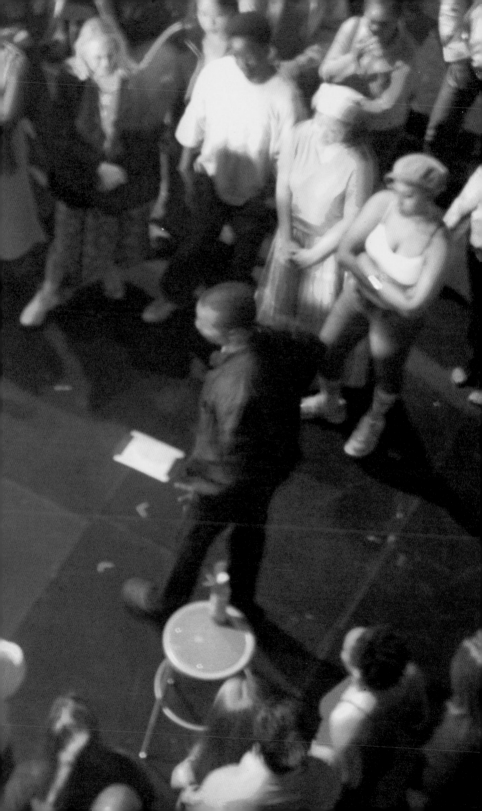

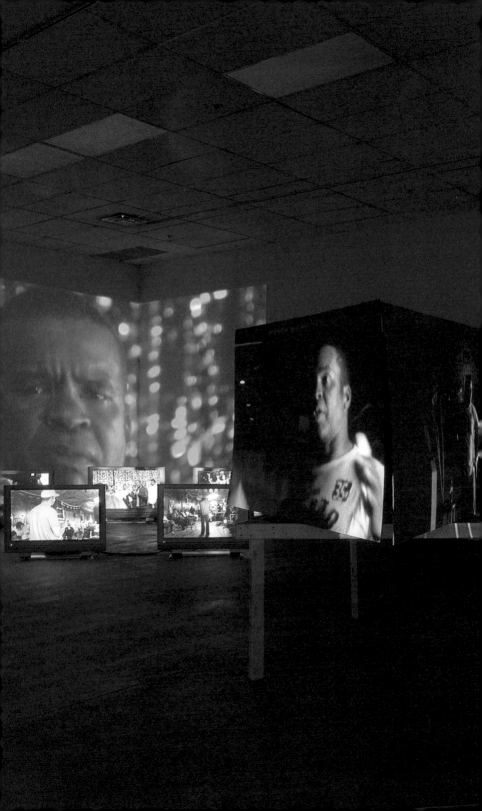

# FATHERHOOD IS PURELY BIOLOGICAL

*I'll end with a song that's yet to be written.*

—David Alan Grier

How do we know things? What constitutes knowledge? What do the limits of knowledge mean? From the word play of his early drawings to the refined combinations of conceptual references in his recent large-scale installations, these are the axes around which Edgar Arceneaux's work revolves. In some of his projects knowledge and discourse are outright subjects of the work. In others they are the structure and system.

Arceneaux's formal repositionings, juxtapositions, repetitions, and occlusions and his conceptual associations across history, geography, culture, class systems and disciplines create non-linear associations of logic and open ended formats that make what and how we know the very subject of our viewing. There is a way that Arceneaux makes us perceive that we are making sense of the works. Dense with images and conceptual associations, his installations slow us down and string us along. We have to make a commitment to interpretation, which puts us within the work and its processes, connecting its threads as we unravel the logic.

Arceneaux's *Rootlessness: Sugar Hill, A Heuristic Model* (2002) proposes this interpretive necessity in its very title. Heuristic models are those in which you discover or learn something by yourself. In *Rootlessness*, a viewer navigates Arceneaux's drawings of actors from Alex Haley's 70s miniseries *Roots*, the actors' images from other roles, and several sculptures created from crystallized sugar, including an upside down sugar-encrusted and ravaged copy of the book *Roots*. The genealogy of actors' careers is refracted through the lens of *Roots'* persistent legacy. But the reliability of *Roots'* account of history is

complicated by the actors' reappearance in radically different roles and by the crystallized concealment of the book. According to Arceneaux:

> Haley took this fractured history and made it whole, creating a linear bloodline all the way back to Africa. Politically it gives agency, which I can appreciate, but as at the same time that history and what came to be known as the idea of blackness in the U.S. became very, very rigid. So part of the project for me was trying to figure out a different way of constructing relationships.[1]

In the twin 2003 projects, *Library as Cosmos* and *Library as Chaos*, Arceneaux creates interwoven matrices from Jorge Luis Borges' "The Library of Babel," Umberto Eco's *The Name of the Rose*, the great library of Alexandria, chaos theory, cartography and the Hollywood technique of matte painting. Like Borges' labyrithian library chaos theory is a reasoned method for irrational and infinite resources. Both can be understood as schema that revealed the limits and determinates of existing systems of knowledge. In the *Library* projects, Arceneaux created multi-dimensional maps that send the viewer on trajectories by which forms of knowledge can be outlined and identified.

In *The Alchemy of Comedy...Stupid* Arceneaux reveals most clearly what is at stake in this exploration of knowledge. Connecting the elusive book at the center of *Name of the Rose*, Aristotle's lost *Book of Comedy*, to elements from his 2004 film project of *An Arrangement without Tormentors*, which used a mathematical system to structure a filmic performance, Arceneaux has developed a project that turns the knowledge creation explored in previous works to the question of legacy explicitly investigated in *Rootlessness* but implicitly considered in all his installations.

Aristotle's account of comedy may have been a starting point for Arceneaux's project, but Arceneaux refers only obliquely to the lost book. Instead contemporary comedic forms interest him and structure the project. One such form is malapropism. As Arceneaux writes in his notes for the project, a malapropism is the "misuse of a word through confusion with another word that sounds similar, especially when the effect is ridiculous." Such as Hollywood producer Samuel Goldwyn's famous twists of phrase, like, "Why did you name him Sam? Every Tom, Dick and Harry is named Sam!" The misuse creates internal, paradoxical contradictions in the structure of the

sentence, but somehow the statement is both funny and its intended logic is still clear.

A second comedic concept of interest to Arceneaux is the cut. In stand-up routines the punch line comes as a cut that breaks the logic of the initially established narrative line of the joke. The cut occurs when the developing story is "smashed by another line of thinking." Rodney Dangerfield was a classic punch line comedian. A Dangerfield joke, for example, goes "Oh, my wife loves vacations. The other night she told me, 'I wanna go someplace I've never been before.' I took her to a men's room."[2] The punch line disrupts the system of the story, reversing it or sidetracking it.

Arceneaux doesn't use the cut as a mere punch line. His cut is architectural, filmic, and aural. The cut is a structural concept. It reveals how a joke works. *The Alchemy of Comedy...Stupid* uses this practice as its aesthetic mode. The project seems to offer straight-forward documentation of a comedy routine. Pictured repeatedly from screen to screen and projection to projection is David Alan Grier, the Hollywood actor, the proven comedic success and star of the classic and side-splittingly funny *In Living Color*. Arceneaux shot four performances of Grier performing new material in three different locations on three different nights in the spring of 2005. Two to three video cameras captured each performance. During the performances, on a regular pattern independent of the rhythm of Grier's routine, the spotlights of the performance space shifted through a spectrum of deep saturated hues. The color could be said to correspond with emotional tones as well as to the four medieval humours (blood, black bile, yellow bile, phlegm) which also correspond to the central alchemical elements (air, earth, fire and water). The cameras circled Grier and weaved in and out of his audiences—audiences that grew exponentially in size over the three nights.

In addition to multiplying Grier's routines, Arceneaux reconfigures them by editing several sound channels with significant sound breaks. One version of a story dealing with the relationship between Grier and his father cuts to silence abruptly after Grier says, "I remember I was crying." A line from a cancer diagnosis story is isolated in the audio of the wall projection, "In the x-ray I saw it." Stretches of routines can be heard to stop, then pick up soon thereafter in the middle of a following segment. Grier can be heard to start a routine several times. A few jokes stop mid story. Others repeat in different forms from the

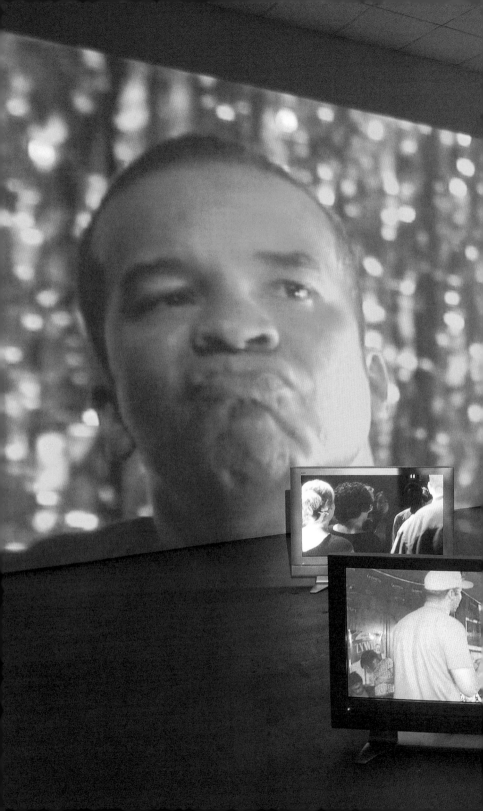

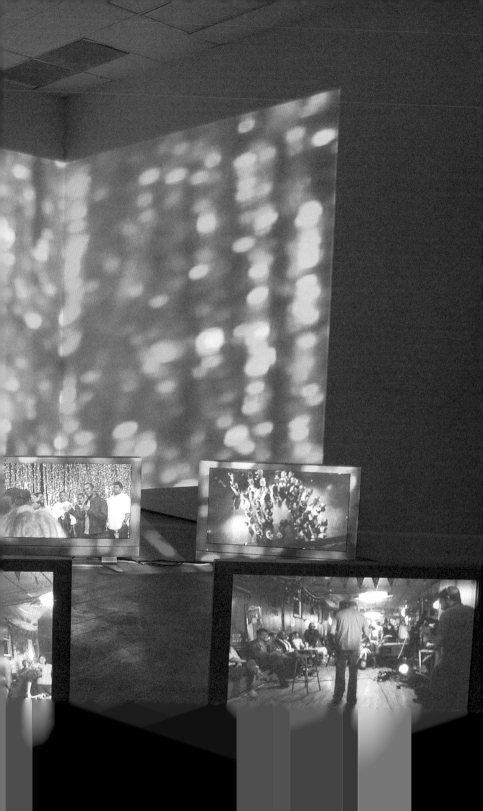

different nights. But no version of a routine runs from start to finish. Arceneaux creates his own cut with the non-narrative soundtrack. It not only cuts the flow of the expected comedy routine, it reveals the shades of the project's overall logic.

In the exhibition space the nine channels of video play on three different surfaces within an over-all triangular configuration. In the foreground at the apex of the installation onto a triangular sculpture of cardboard screens are projected three views from the first night of Grier's performances. Here, in the cavernous octagonal atrium of a generic university building Grier debuted a new routine for next to no audience, just the video crew and a few randomly passing night custodians. The footage on one side of the sculpture spotlights Grier in profile. Another looks over his shoulder at the dark emptiness he faces. The third view is a bird's eye on the margins in which a spectral character watches and sporadically comments. As the audience member who might not be paying attention or is criticizing Grier this character could stand in for the comedian's self-consciousness or his worst nightmare, the audience member who doesn't laugh.

Beyond the triangular set of videos are the second and third nights of performance on two banks of video flatscreens. In the front row are two flatscreens on which Grier is shown in a cramped bar with lighting accoutrements and wiring strewn about him. Mimicking the distraction of the audience, some of whom watch Grier while others have conversations or play pool, one channel of footage follows Grier through the routine while the other tracks through the audience, across the pool table or down onto the floor. The second row of three flatscreens shows Grier on a traditional theater stage surrounded by a thick, close crowd. Two of the cameras track in, around and through the crowd. The third gives us an aerial view. Looming large over these banks of monitors is a wall projection of Grier in close-up, running through the routine alone.

Jokes in general are often used to confront the difficult, disturbing and distressing. Heard clearly from beginning to end is a particularly funny impersonation Grier does of an ex-girlfriend's best friend's account of how exaggeratedly wonderful the ex-girlfriend's new life is. Grier follows with a downtrodden wallow in the comparative miseries of his own life. There are other jokes with easy targets: Paris Hilton, Michael Jackson, new moms, San Francisco liberals. But Grier strikes a personal tone, a tone that perhaps reveals a touch of depression,

in many of the stories. Grier plays this up in an often-repeated joke involving a doctor's visit and Grier's cancer diagnosis. His gown doesn't fully cover. The MRI technician mistakes him for a Wayans brother. When the crowd is close to him expectation, concentration, skepticism, and momentary enjoyment cross the faces of the spectators. But the story does not let up. It is uncomfortable. Until Grier undermines the mood.

A long section of the comedic routine, and one heard repeatedly in the soundtrack, is given to a very unfunny story relating a young Grier trying to cope with his parent's divorce, and in particular his father's absence. In an argument 10-year-old Grier had with his father, his father ends the discussion with, "Fatherhood is purely biological." This key moment in Grier's routine is isolated as a large rendering of handwritten text on the gallery wall. In the telling, this narrative moment is heartbreaking. As a simple statement, though, it is paradoxical. One could accept the father's statement and say fatherhood is reducible to biology, if not for the pain the statement reveals. Later in his routine Grier turns this bitter phrase into a punch

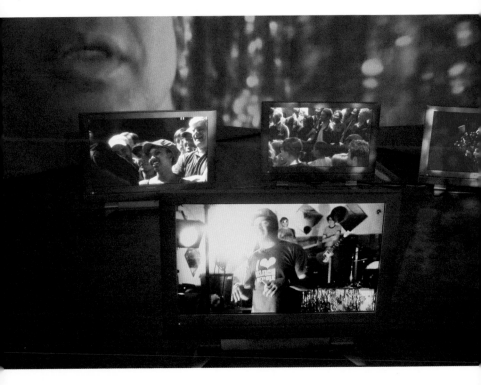

line. He uses the very same line years later to deny his dad money, playing up a deep, cutting irony.

Within the installation this statement is a pivot point reinforced by two large works on paper. One entitled *Richard Burnt Up and Crippled* pictures a wheelchair with burning embers in the seat. Though Grier's story about his father reveals that his father now uses a wheelchair, the charred person referred to in the title is Richard Pryor, a comedian who could be considered a father figure for the younger Grier. Pryor and Grier's father are ghosts in the installation. They aren't represented bodily; the wheelchair stands in for them. They have no voice; Grier represents his father's voice and words. But the two older men haunt the exhibition in their relationships to Grier, in the inheritance they have left to Grier.

In the second drawing a burning monk is pictured under lines of text from the Old Testament of the bible. The text is from the story of Moses' encounter with the paradoxical burning bush. "He gazed and there was a bush all aflame, yet the bush was not consumed." The burning monk, too, is a paradox, especially when considered from a Christian faith. In a 1965 letter to Dr. Martin Luther King, the Vietnamese monk Thich Nhat Nanh wrote:

> The Press spoke then of suicide, but in the essence, it is not. It is not even a protest. ... To burn oneself by fire is to prove that what one is saying is of the utmost importance. ... The importance is not to take one's life, but to burn. What he really aims at is the expression of his will and determination, not death. ... To express will by burning oneself, therefore, is not to commit an act of destruction but to perform an act of construction, i.e., to suffer and to die for the sake of one's people. This is not suicide.[3]

But the text about the burning bush reveals another aspect of Arceneaux' project in *The Alchemy of Comedy...Stupid*. Arceneaux has cut off the last part of the burning bush story. Moses gets close to the bush and God calls Moses' name. To which Moses answers, "Here I am." Arceneaux cuts the text off there and adds an ambiguous, "WHO ME" to the text as though God is playing a joke on Moses. Or maybe it's Moses' joke. The missing part of the Old Testament text is, "Don't come any closer. This is holy ground. I am the God of your Father".

What Arceneaux does with *The Alchemy of Comedy...Stupid* is throw lineage, patrimony and inheritance into question. "Fatherhood is purely biological" is an emotional lesson for a child. But fatherhood also can be understood as heritage, legacy, the history of knowledge.

Now Moses, tending the flock of his
father-in-law Jethro, the priest of Midian,
drove the flock into the wilderness, a
came to Horeb the mountain of God. An
angel of the Lord appeared to him in a
blazing fire out of a bush. He gazed, and
there was a bush all aflame, yet the bush was
not consumed. Moses said "I must turn aside
to look at this marvelous sight, why doesn't
the bush burn up?" When he Lord saw that he l
turned aside to look, God called to him out of th
"Moses! Moses!" He answered, "Here I am."
(Exodus 3:1-4) WHO ME

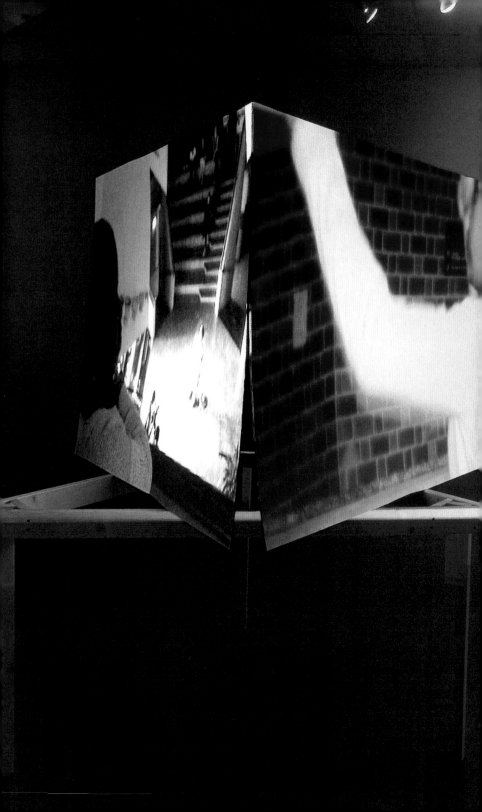

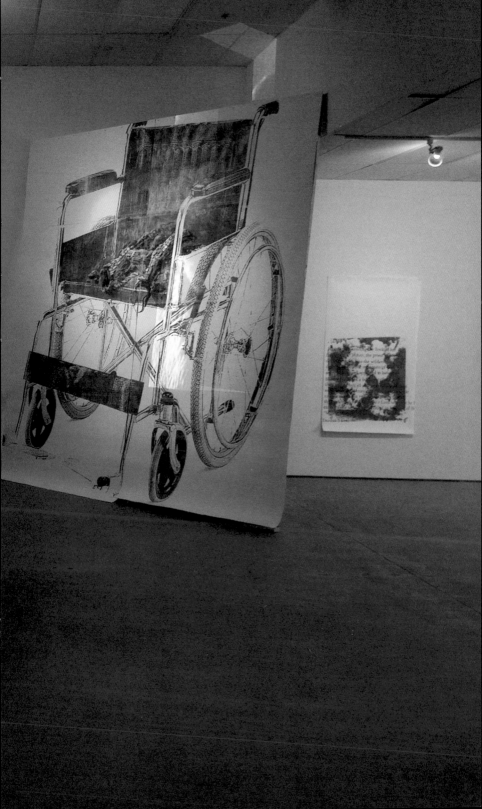

Here the fatherhood of systems of knowledge or of intellectual inheritance isn't biological, isn't scientific. As with *Roots* and Aristotle's lost *Book of Comedy* legacy can be interrupted, diverted, misinterpreted or rewritten. The history of knowledge has been marked by misconception and outright deception. But within the fragmented terrain of established knowledge are opportunities for transforming and expanding knowledge. We cannot deny our legacy, our inheritances, but we can determine how they get retold. Turn them into malapropisms or punchlines.

In the Introduction to *The Archeaology of Knowledge* Foucault poetically writes about his own method and the questions the reader will pose to him about what might be regarded as a change of method. He muses that the reader might ask, "Are you already preparing the way out that will enable you in your next book to spring up somewhere else and declare as you're now doing: no, no, I'm not where you are lying in wait for me, but over here, laughing at you?"[4]

As answer to this rhetorical question Foucault implies that he is preparing "a labyrinth into which I can venture, in which I can move my discourse, opening up underground passages, forcing it to go far from itself, finding overhangs that reduce and deform its itinerary, in which I can lose myself and appear at last to eyes that I will never have to meet again."[5] In other words, "Who me?"

Lorelei Stewart, Director

Gallery 400
University of Illinois at Chicago

[1] From a conversation between Edgar Arceneaux and Aimee Chang, January 30, 2003 as quoted in Aimee Chang, "Opening the Work," in Edgar Arceneaux, *Lost Library* (Ulm, Germany: Kunstverein Ulm, 2003), 15.

[2] Rodney Dangerfield, *Rodney's Archive: Joke Archive: Jokes for September 2006: September 17*, www.rodney.com/rodney/archive/archive.asp (9/28/06).

[3] Thich Nhat Nanh, "In Search of the Enemy of Man (addressed to (the Rev.) Martin Luther King)," In Nhat Nanh, Ho Huu Tuong, Tam Ich, Bui Giang, Pham Cong Thien, (*Dialogue*. Saigon: La Boi, 1965), 11-20, as cited on African American Involvement in the Vietnam War, www.aavw.org/special_features/letters_thich_abstract02.html (8/13/06).

[4] Michel Foucault, *The Archaeology of Knowledge and the Discourse on Language*, trans. A. M. Sheridan Smith, (New York: Pantheon Books, 1972) 17.

[5] Foucault, 17.

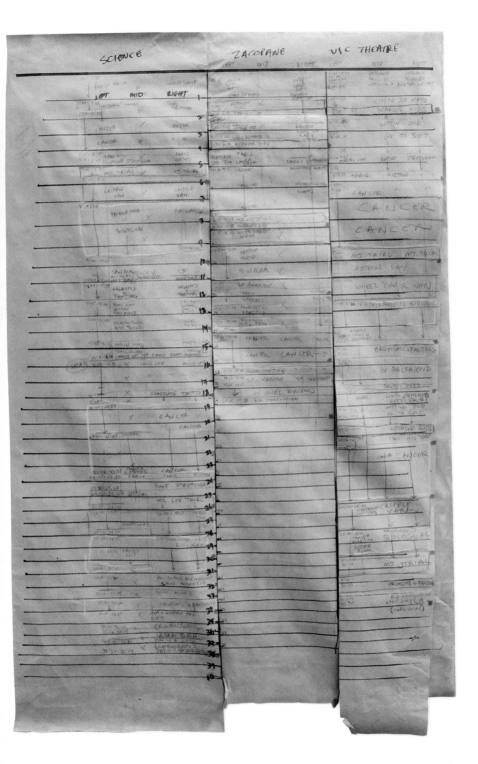

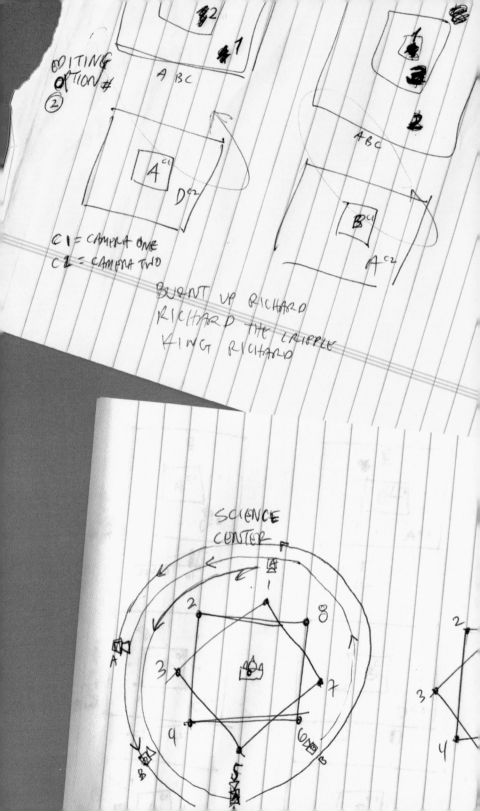

EDITING
OPTION #
②

A BC

☆2
☆1

$A^{c1}$

$D^{c2}$

C1 = CAMERA ONE
C2 = CAMERA TWO

☒
☒3
☒2

ABC

$B^{c1}$

$A^{c2}$

BURNT UP RICHARD
RICHARD THE CRIPPLE
KING RICHARD

SCIENCE
CENTER

♔

**FORE FRONTED**

**VIC THEATRE**

2

1  3

A B C

C $^{c1}$

B $c2$

**STRATEGY**

GOING THROUGH
LEVELS OF
OPACITY & TRANSLUCENCY
SUPERIMPOSITION OF
LOCATIONS, DISCONTINUITY
OF TIME, SOME
ENDING WHILE OTHERS
STILL CONTINUE TO
RUN.

WHAT ABOUT THE
SOUND ??? HOW TO
DEAL W/ THE NOISE OF
MULTIPLE SOURCES ?

D $^c$

C $^{c2}$

**QUESTION**
HOW TO

FORDPANE

8

7

6

**VIC THEATRE**

2       8

3                7

4          6

5

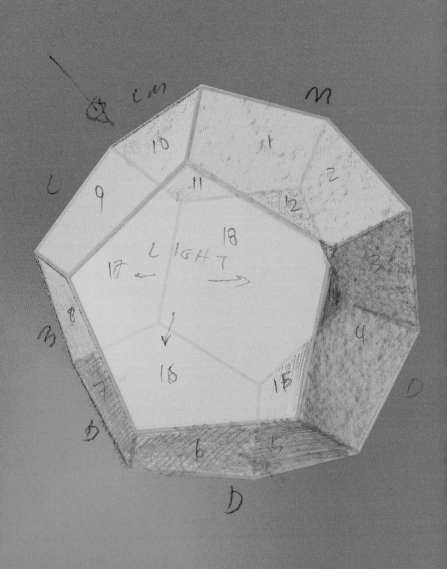

A PARADOX CAN BE A LOGICAL SELF-
CONTRADICTION.

INTUITION IS AN UNCONSCIOUS FORM OF
KNOWLEDGE. IT IS IMMEDIATE & NOT OPEN TO
RATIONAL/ANALYTICAL THOUGHT PROCESSES. IT
DIFFERS FROM INSTINCT, WHICH DOESN'T HAVE
THE ELEMENT OF EXPERIENCE. IT IS THE HIGHEST
FORM OF SKILL ACQUISITION.

INTUITION HAS ADVANTAGES IN SOLVING COMPLEX
PROBLEMS AND FINDING NEW RESULTS.

INTUITION IS ONE SOURCE OF COMMON SENSE

SOURCES OF INTUITION ARE

- FEELINGS
- EXPERIENCES
- KNOWLEDGE

I HAVE INTUITED A RELATIONSHIP BETWEEN
ALCHEMY AND COMEDY AND THEIR PROPERTIES
IN WHICH THEY SHARE. IT IS PR I AM
OPERATING UNDER THE BELIEF THAT THE
METHODOLOGY OF ALCHEMY CAN BE APPLIED TO
THE STRUCTURAL WORKINGS OF COMEDY

M   C

T
PPP

AXIS OF SENTIMENTA
INTEREST FICTION BASED

COMEDY

TRAGEDY         SENTIMENT

TOTAL EMOTIONAL
DIVIDE

I had a great day here in Chicago, it was beautiful...

Did you have a nice Cinco de Mayo?

(SCREAMS) CINCO DE MAYO! YAYAYAYAYAYAYAYA!

The Mexican St. Patrick's Day.

There's one thing that I love about Cinco de Mayo, it just means so much to the African American community. It's about Mexicans beer and whoop' ass! It was wonderful, I got my Cinco on.

I love Chicago, you know, you guys are so nice. I was checking into the hotel yesterday, I checked in and I got on the elevator with a really large group of severely retarded kids.

# AND I'M SAYIN', YOU DON'T USUALLY SEE RETARDED KIDS ON VACATION.

They were bugging out, it was nice, I hung out with them all day. It was beautiful, I never felt so superior in all my life. I was TOP DOG! I knew everything I was the smartest dude on the planet. And I was like 2 + 2 is 6 you idiot! Stop hugging me Jimmy, who's picking boogers!

I get my physical every year. Physical time, I went to my doctor, and it usually goes something like this. I get the tests, the urine test, the blood test, and the doctor usually says, "go home, if I don't call you, assume everything is fine."

So I go home this year, and about a day and a half later, they call me. "I don't want you to worry, just want to ask you a couple questions. Have you been in a car accident?" Yeah, I'm like that's not something that you just like uh... "you mean have I seen a car accident?"

"Have you suffered any blunt force trauma?"

"Do you mean fightin', boxin', or what? No."

"I mean did someone hit you with a brick, a baseball bat?"

"No. Well, I think that you should come in. I think we found somethin' I don't want you to freak out".

Of course I freaked out, I was like (sound of crying, sniffling). I was waving at everybody, I went in there, and he said "I think we found somethin' in the x-ray. I want to send you a cancer spec...". "Excuse me?"

"Cancer specialist over at Cedar Sinai Hospital, don't be concerned."

So I go to the cancer specialist and they put me in one of those hospital gowns, my ass is all hanging out, the hemline is two inches above my nut sack. They doin' heart transplants, but they cant figure out the hem needs to be a little lower?

# THE NURSE COMES OUT, "OH, YOU THE ACTOR, THE FUNNY MAN. YOU KNOW THAT THIS IS THE CANCER WARD, RIGHT?"

So she put me in the MRI, it's a stand up MRI, it state of the art, it wraps around your body, there's a big flat screen TV. It felt like a bad situation. So I see this thing and I am like "doctor is that?" cause he's not in the room and he's like, "TURN LEFT PLEASE! STOP WITH THE JOKES, THIS IS VERY SERIOUS!".

"Gee, is that my kidney?" "No that's not your kidney, David, that's what we're looking at." "That looks like a potato?!?" The doctor tells me, "I need to talk to you, you have cancer". Cancer. cancer, cancer...

Cancer.

3)

PARIS HILTON

2)

FAKE CANCER
PhysICAL EXAM
Lump - BAC

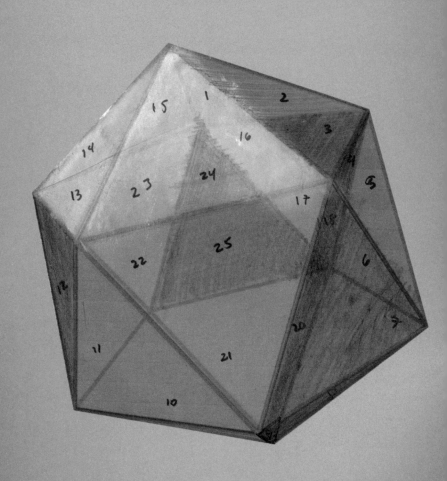

"The Three Domains of Creativity" Arthur Koestler, one of the more important writers who treat conceptualization (THE PROCESS BY WHICH ONE HAS IDEAS.) identifies these "domains" as

ARTISTIC ORIGINALITY  (he calls the "ah" reaction)

SCIENTIFIC DISCOVERY  (THE "aha" reaction)

COMIC INSPIRATION (THE "HAHA" reaction)

He defines creative acts as the combination of previously unrelated structures in such a way that you get more out of the emergent whole than you have put in.

He explains comic inspiration as stemming from "THE INTERACTION OF TWO MUTUALLY EXCLUSIVE ASSOCIATIVE CONTEXTS" as in creative artistic and scientific acts, two ideas have to be brought together that are not ordinarily combined

SIGN ALL PIECES → Edgar Cockroach

in the case of humor,

"TO PERCEIVE THE SITUATION IN TWO SELF CONSISTENT BUT HABITUALLY INCOMPATIBLE FRAMES OF REFERENCE"

THE JOKE TELLER TYPICALLY STARTS A LOGICAL CHAIN OF EVENTS.

THE PUNCHLINE THEN SHARPLY CUTS ACROSS THE CHAIN WITH A TOTALLY UNEXPECTED LINE.

THE TENSION DEVELOPED IN THE FIRST LINE IS THEREFORE SHOWN TO BE A PUT-ON AND WITH IT'S RELEASE, THE AUDIENCE LAUGHS.

THE DEVELOPING STORY PRODUCES TENSION IN THE LISTENER, WHO DESIRES TO KNOW THE OUTCOME IS SMASHED BY ANOTHER LINE OF THINKING WHO DEMONSTRATES TO THE THINKER/LISTENER THAT THE WHOLE THING IS A FARCE.

RESEARCH VULGARITY

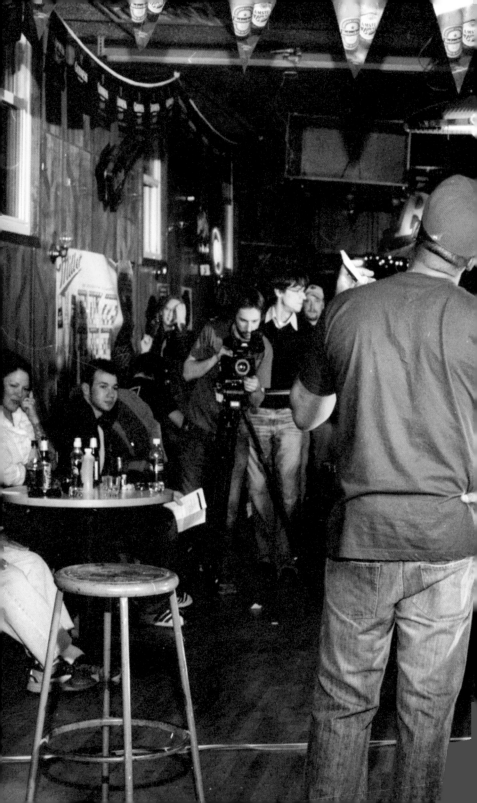

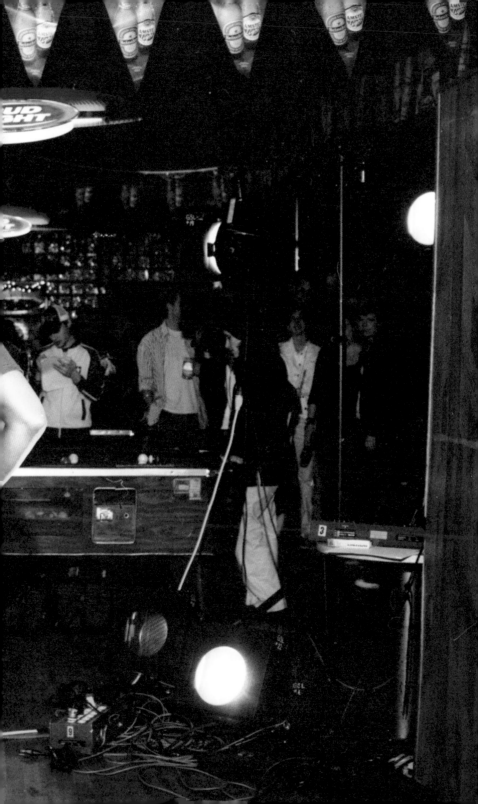

UM...I DID SOMETHING A LITTLE CRAZY, I GOT A UH...A TATTOO. AND FOR ME IT WAS THE FIRST TATTOO THAT I EVER GOT. AND I KNOW NOW THAT IT IS ALL PASSE, CAUSE EVERYBODY'S GOT TATTOOS. SO I REALLY TRIED TO DO SOMETHING A LITTLE DIFFERENT.

# I GOT A BROWN TATTOO OF A CHOCOLATE BAR RIGHT ACROSS MY CHEST.

4) Shoe Stretch...

EXTRA STUFF
New TATTOO
Choc BRWN

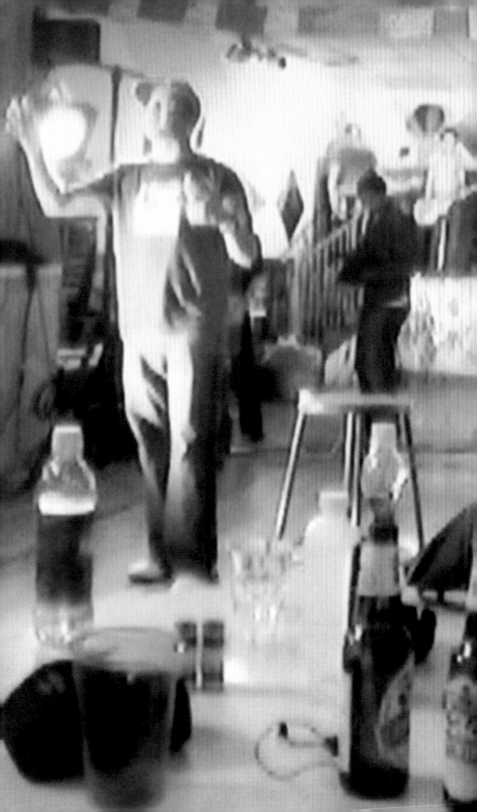

ROPE

OLD LACE + ARSCINCH

(LEATHER)
CASE
W/THE NAM

FART

NOT FUNNY)

HOLLYWOOD
FILMS BODIES IN BOXS
ROPE

- OLD LACE +
ARSCENICH

' BOXING HELENA

TELEVISION

- TELEVISION THAT
IS PLAYING T.V.
SHOWS w/ ANOTHER
MONITOR w/ JOKES
* PLAYING (TEXT PIECE)

- PLACE A PAINTING ON
THE T.V.

TURD
CHEETOH
CORN CHIP
RAP
AMBIVILENCE

THE CRITICAL POINT IS THAT A SIMILAR REACTION (LAUGHTER) MAY GREET AN ORIGINAL IDEA.

A CONCEPT MAY BE ~~SO~~ COMPLETELY CONTRARY TO ~~THE~~ LOGICAL PROGRESS OF THE PROBLEM SOLUTION

(THAT IT COULD CAUSE A TENSION RELEASE AND CAUSE LAUGHTER)

PARADOX IS A LOGICAL SELF CONTRADICTION.

## VULGARITY

# UNDERNEATH LIES UGLY SURFACES

## PAINTED SURFACE

BREAKING RULES OF PAINTING FORM
BAD MASTER COPIES

### VIDEO

~~HOME~~ ~~VIDEO~~ FOOTAGE SUBTITLES

WITH ~~THE~~ ~~THE~~ MUSIC VIDEO'S
- B/W MOVIE ETC.
- T.V. SHOWS.

## ~~IMAG~~ PHOTO'S

TRULY UGLY PHOTOGRAPHS
UNINTERESTING
- OUT OF FOCUS.
- THROWN AWAY SNAP SHOTS ETC.
- POORLY PRINTED ETC.

## RESIDUE OF NATURE LEFT OUTSIDE TO THE ELEMENTS.

- CANVAS LEFT ON GRASS FOR 3 ~~DAYS~~ WEEKS

- ON HILL OF PARENTS HOUSE FOR 3 MONTHS.

SET A COST LIMIT LOW FOR WHOLE SHOW.

MEANS OF PRODUCTION COSTS OF MATERIALS SHOULD BE LOW

6) My Dads' New Van

7) Fatherhood is .
purely Biological

EPIGRAM :① A CONCISE WITTY, AND OFTEN
PARADOXICAL REMARK OR SAYING

LEO
ROSTEN'S
CARNIVAL
OF WIT.
1996

② A SHORT POEM, OFTEN EXPRESSING A
SINGLE IDEA, THAT IS USUALLY SATIRICAL
WITH A WITTY END

WIT

- COLERIDGE SAID: WHAT IS AN EPIGRAM?
A DWARFISH WHOLE
IT'S BODY BREVITY
AND WIT ITS SOUL.

- DOROTHY PARKER : " WIT HAS TRUTH IN IT; WISE
CRACKING IS SIMPLY CALISTHENICS
W/ WORDS."

WORDS CONVEY, RELATE, CONTEND; WIT DANCES. IT
ENDOWS DATA W/ DELIGHT. IT BUBBLES WITH A
SENSE OF MISCHIEF. IT IS ALWAYS IMPUDENT
IRREVERENT (LACKING RESPECT), CORROSIVE - AND
SOMEWHAT ARROGENT.

THE MOST EFFECTIVE WIT CASTS A SUDDEN AND
SURPRISING (OFTEN CYNICAL) LIGHT ON FAMILIAR
OBJECTS.

IE. "FASHIONS ARE INDUCED EPIDEMICS" - GEORGE BERNARD
SHAW
" A YAWN IS A SILENT SHOUT!" - G.K. CHESTERTON

BLACK HUMOR MAY BE DEFINED AS CALCULA
DARK
VULGARITY, OR OUTRIGHT OBSCENITY DESIGNED
DISGUST ANYONE OVER FORTY.

LAUGHTER HAS NO BIOLOGICAL PURPOSE: IT ONLY
PROVIDES RELIEF FROM TENSION.

LAUGHTER, TECHNICALLY SPEAKING IS A MOTOR
REFLEX PRODUCED BY THE COORDINATED INTERPLAY
OF 15 MUSCLES, IN A CONTRACTION OF 15
DIFF. FACIAL MUSCLES ACCOMPANIED BY
SIGNIFICANTLY CHANGED BREATHING.

WIT IS AN ADULT CREATION. IT LIES IN THE
PROVINCE OF INTELLIGENCE AND ACUITY IN
MANIPULATING LANGUAGE. VERBAL
                                        DECEPTION

OF ALL THE SEXUAL ABERRATIONS, THE
MOST PECULIAR IS CHASTITY —REMY DE
                                        GOURMONT

LOOK AT FREUD AND HUMOR

EPIGRAMS MORE CLEVER THAN TRUE, PRIZED BY
INTELLECTUALS MORE THAN BY THE MASSES. PROVERBS ARE
PACKAGES OF HUMAN EXPERIENCE. THEY ARE A PEOPLE
PRIMER OF LIVING —AND FOLK SAYINGS ARE THEIR HOME
BROTHERS. BOTH DISTILLED FROM COMMON SENSE

# VULGARITY

AFTER ALL MAGAZINE
ARTICLE ON RICHARD WRIGHT
BY ?

Rock music formulates a cult of pure participation;

Art culture idealises certain notions of participation but tend to understand itself as a space of judgement and critique. Robert Pattison understands the connection between rock and romanticism in terms of dual concepts of vulgarity and pantheism.

Vulgarity in art does not indicate 'BAD TASTE' but rather no taste at all, a form of blankness that is above all a refusal to recognise any of the hierarchies of values or distinctions that give meaning to all notions of tradition or history. Translated to rock's own terms, vulgarity becomes the practical application of the principle of IMMEDIACY, an upfront celebration of a subject that is 'nothing' but an effect of momentary, fleeting passions and sensations — coupled with an equally upfront and explicit rejection of all transcendental principles that

would threaten to fixate those sensations in
a schema of logic or reason.

WITTICISMS ARE STRATEGIES TO EVADE
THE CENSORS OF POWER, THAT COMEDY IS A
COMPLEX MASQUERADE, (AND) THAT MURDER
OFT PEERS THROUGH THE MASKS OF OUR
WIT; THAT HUMOR IS THE MESSENGER OF
TRUTHS THAT CHURN BEHIND THE
CAMOUFLAGE OF LEVITY, THAT

WICKED IN A
PLAYFUL WAY
WITHOUT CAUSING
SERIOUS HARM

MOCKERY IS THE MOST [IMPISH] AND AGILE
OF STRATAGEMS DEVISED TO PUNCTURE THE
PLATITUDES THAT STIFLE ALL OUR MINDS
AND STRANGLE ALL OUR PRESCIOUS MISCHIEF.

[PARODY]
PARODIES SEEM TIED TO DETERIORATING INST.'S
CANON'S, TRADITION, ETC. UNDERMINE AN
ESTABLISHED SET OF FORMS. CERVANTES'S DON
QUIXOTE (1605-1615) PARODIES CHIVALRIC
ROMANCES. ARISTOPHANES BRILLIANTLY PARODIED
EURIPIDES.

DRAWING AS ERROR - APPROXIMATION - (PARODY OF
                    FORM?)

PARODY IS A MOCKING IMITATION IN VERSE OR
PROSE

EPIGRAMS        PROVERBS

THEY ARE INHERITED FROM THE PAST
DISTILLED FROM COMMON SENSE
PORTABLE WISDOM, THE SCHOOL OF THE UNTUTORED

**GAG :** COMES FROM CIRCUS CLOWNS, VAUDEVILLE AND SILENT MOVIES. UNDERLINE VISUAL COMEDY . ~~EARLY~~ LATE NIGHT TALK SHOW WRITERS.

**ONE LINERS :** A FUNNY LINE WITH IT'S OWN BEGINNING, MIDDLE, AND END. A MODERN STAPLE OF STANDUP COMICS, MASTER BOB HOPE, MILTON BERLE, MASH, MARY TYLER MOORE SHOW, ALL IN THE FAMILY

RODNEY DANGERFIELD:

I SAID TO MY MOTHER-IN-LAW LAST YEAR, "MY HOUSE IS YOUR HOUSE." THE NEXT DAY SHE SOLD IT.

4-11-93 HENRY YOUNGMAN:

HOW DO YOU GO ABOUT WRITING YOUR ONE LINERS? ASKED THE REPORTER. "I DON'T WRITE THEM, I BUY THEM... I NEVER WROTE A JOKE IN MY LIFE."

**DERIVATIVE**

↓

HOW DO YOU GO ABOUT COMING UP WITH THE IDEAS FOR YOUR WORK? ASKED ~~THE REPORTER~~ I DON'T ~~COME UP WITH~~ CREATE THEM, I BUY THEM... I NEVER ~~THOUGHT~~ THOUGHT UP AN IDEA IN MY LIFE."

## PUNS

THE MOST FREQUENTLY ATTEMPTED FORM OF WIT VIA WORDPLAY → USUALLY BANAL - ORDINARY LACKING IN ORIGINALITY

NONE BUT THE BRAVE
DESERVE THE FAIR — WILSON MIZNER

MY GRANDMOTHER IS OVER 80 AND STILL DOESN'T NEED GLASSES. DRINKS RIGHT OUT OF THE BOTTLE — HENNY YOUNGMAN.

### ※※※ MALAPROPISM

MALAPROPISM: THE MISUSE OF A WORD THROUGH CONFUSION W/ ANOTHER WORD THAT SOUNDS SIMILAR, ESPECIALLY WHEN THE EFFECT IS RIDICULOUS.

MALAPROPOS: NOT APPROPRIATE TO THE SITUATION IN WHICH SOMETHING IS DONE OR SAID (FORMAL USAGE)

ADV.
IN AN INAPPROPRIATE WAY OR AT AN INOPPORTUNE MOMENT.

PEOPLE WHO GARNER LAUGHTER THROUGH A BOO-BOO, MALAPROPISM, OR OTHER FRACTURED ENGLISH AND ARE SUPRIZED BY THE LAUGHTER THAT SOME WORD, PHRASE OR IDIOM ELICITS.

———————→

LYOTARD FOUND IN THE KANTIAN SUBLIME A USEFUL CONSTRUCTION FOR THE DEVELOPEMENT OF AN AESTHETIC THEORY OF CULTURE. IN MODERNISM, OUR SYSTEMS OF KNOWLEDGE, SCIENCE, ART AND HISTORY OPERATE WITHIN A CONTEMPORANEITY DESCRIBED BY KANT AS A CONFRONTATION WITH THE PRESENT AND THE URGE TO FIND A WAY OUT (AUSGANG) AUSGANG

AUSGANG, AN EXIT. THIS URGE OFTEN

↓

AN URGE TO FIND A WAY OUT OF THE PRESENT

THAT IS THE LOGIC OF THE JOKE! THAT MOMENTARY SLASH OF LOGIC, THE MOMENT OF LAUGHTER IS A BREAK FROM A CONTIGUOUS REALITY (HISTORY) BOUNDED BY RULES AND ORDERS.

DESCRIBED AS A BREAK FROM TRADITIONAL SYSTEM OF THOUGHTS (HISTORICAL PARADIGMS) IS WHAT BAUDELAIRE CALLED "THE EPHEMERAL, THE FLEETING, THE CONTINGENT." LYOTARD REFERS TO IT AS FEELING DESCRIBED IN THE KANTIAN SUBLIME

THE POST MODERN SUBLIM (AS STATED BY LYOTARD)

A SENTIMENT, A FEELING THAT IS PRODUCED IN US WHEN REPRESENTATION FAIL WHEN OUR IMAGINATION FAILS TO FIND AN INSTANCE OF AN IDEA.

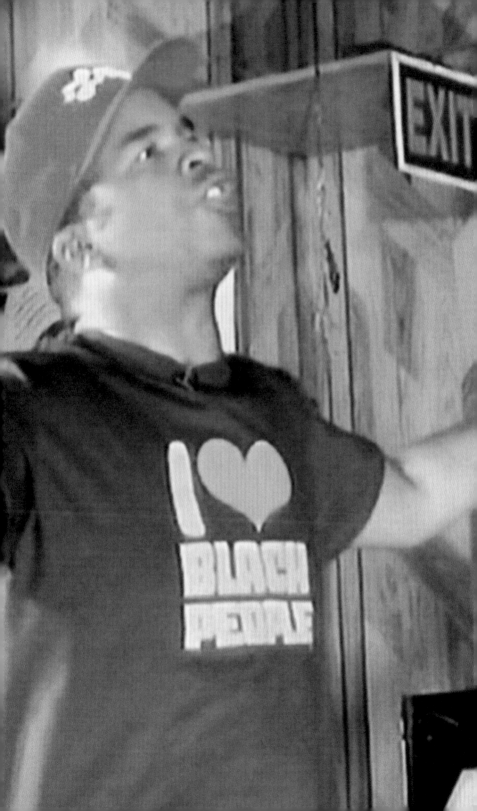

# ALCHEMY

to understand alchemy it is helpful to understand how magical the conversion of one substance into another, which formed the logic of metallurgy since its inception at the end of the neolithic period (end of THE STONE AGE) would seem ~~at the end of~~ in a culture with no formal understanding of physics or chemistry.

FOR THE ALCHEMIST, THERE WAS NO REASON TO SEPERATE THE CHEMICAL/MATERIAL DIMENSION FROM THE INTERPRETIVE,
          SYMBOLIC OR
          PHILOSOPHICAL ONE

IN THOSE TIMES, A PHYSICS DEVOID OF METAPHYSICS INSIGHTS WOULD BE PARTIAL + INCOMPLETE AS A METAPHYSICS DEVOID OF PHYSICAL MANIFESTATIONS

ALCHEMICAL PROCESSES OFTEN HAD BOTH AN INNER MEANING AND A MATERIAL MEANING

SPIRITUAL DEVELOPMENT OF THE PRACTICIONER

CONNECTED TO THE PHYSICAL TRANSFORMATION OF MATTER

BASE METALS
→ GOLD

TRANSMUTATION OF METAL INTO GOLD WAS
SYMBOLIC OF AN ENDEAVOR TOWARDS PERFECTION OR
UTMOST HEIGHTS OF ~~NOBLE~~ EXISTENCE.

BELIEVED THE UNIVERSE TENDED TOWARD
PERFECTION & GOLD DUE TO IT'S IMMUNITY TO
DECAY WAS CONSIDERED TO BE THE MOST PERFECT
OF SUBSTANCES. BY ATTEMPTING TO TRANSMUTE BASE
METALS INTO GOLD, THEY BELIEVED THEY WERE GIVING THE
UNIVERSE A HELPING HAND.

ALSO UNDERSTANDING GOLDS IMMUNITY ~~COULD BE~~ MIGHT PROVE
THE KEY TO WARD OFF DISEASE & ORGANIC DECAY, HENCE
THE INTERTWINING OF CHEMICAL
                      SPIRITUAL
                         &
                      ASTROLOGICAL

        THEMES CHARACTERISTIC OF ~~MEDIEVAL~~
        MEDIEVAL ALCHEMY

?

( PAINT
  HIS BODY
  WITH GOLD
  DUST ? )

ALCHEMY DEVELOPED OVER TIME   BEGINNING WITH
  → METALLURGICAL/MEDICINAL ARM OF RELIGION
  → MATURING INTO A RICH FIELD OF STUDY
  → DEVELOPING INTO MYSTICISM AND CHARLATANISM
  → AND IN THE END PROVIDING THE FUNDAMENTAL
    EMPIRICAL KNOWLEDGE OF THE FIELDS OF CHEMISTRY &
    MODERN MEDICINE.

PROSUMER                              PRO.

XL2        ADV100A   |    SDX1000
[ 250/DAY.                   4 - 6 DAY

9

16

4                    3

4

3

A MEDIUM SHOT IN "4:3" IS
LIKE THIS. IN "16:19" THERE
IS ALWAYS A LOT OF SPACE ON
THE SIDES. THIS EXTRA FRAME
INFO WILL BE LOST WHEN TRANSF
TO 16 mm BECAUSE 16 mm IS 4:3
RATIO.

BAUDELAIRE ESSAYS ON COMEDY / HUMOR
LAUGHTER

GOETHE ESSAYS ON = COLOR

---

TRANSMUTATION. A CHANGE OR THE PROCESS
OF CHANGING FROM ONE
- FORM
- SUBSTANCE
OR - NATURE
- STATE
TO ANOTHER

MALAPROPISM. THE MISUSE OF A WORD
THROUGH CONFUSION W/ANOTHER
WORD THAT SOUNDS SIMILAR
ESPERIALLY WHEN THE
EFFECT IS RIDICULOUS

METONOMY: DESCRIBES THE RELATIONSHIP
BETWEEN TWO SIGNS, IT IS DEFINED
BY CATACHRESIS, AMBIVALENCE, CONTINUING
ITERATION. METONYMIC RELATIONSHIPS
ARE NOT BASED ON UNIVERSALIST
MODELS BUT SUBVERSIVE LINGUISTICS
REVEALING INDETERMINATE SPACES
BETWEEN SIGNIFIER/SIGNIFIED.

CATACHRESIS: THE INCORRECT USAGE OF WORDS
FOR EXAMPLE; BY MIXING METAPHORS
OR APPLYING TERMINOLOGY WRONGLY.

ITERATION: TO UTTER OR DO AGAIN;
TO REPEAT

ITIRATION + CATACHRESIS

IS THE COMIC NIGHTMARE...

- "DID I DO THIS JOKE ALREADY?"

- TELLING THE SAME JOKE TWICE

- FORGETTING A LINE

IS A COMEDY TABOO + INDICATES A LOSS OF CONTROL..

DOING SOMEONE ELSE'S MATERIAL AS IF IT WERE YOUR OWN? RICHARD PRYOR STOLE BILL COSBY'S ROUTINE + NEVER INDICATED THAT IT WASN'T HIS MATERIAL. DAVID SUGGESTS WE STEAL DAVE CHAPELLE'S SKIT ON RICK JAMES.

11) WOMEN & ORGASMS

20% OF WOMEN ARE
AFRAID TO CUM

MEN don't CARE

12) BOYS AGAINST G

ROAD RULES REAL
WORLD BATTLE OF
THE SEXES

THERE WERE THREE MAIN GOALS OF THE ALCHEMISTS.

1. TRANSMUTATION OF ANY METAL INTO EITHER GOLD OR SILVER.

2. UNIVERSAL PANACEA; A REMEDY TO CURE ALL DISEASES AND PROLONG LIFE INDEFINITLY. THE PHILOSOPHERS STONE WAS KEY TO THE PROCESS. A MYTHICAL SUBSTANCE WHICH COULD BE A POWDER, LIQUID OR STONE.

3. CREATING HUMAN LIFE

THEY BELIEVED ALL MATTER WAS COMPOSED OF THE FOUR ELEMENTS. THESE ARE GREEK CLASSICAL ELEMENTS A LIST CREATED BY THE ANCIENT PHILOSOPHER EMPEDOCLES

FIRE   IS  BOTH  HOT + DRY
EARTH   "    "   COLD + DRY
AIR     "    "   HOT + WET
WATER   "    "   COLD + WET

FOUR HUMOURS
PLATONIC SOLIDS ———→ IMPORTANCE OF THE

4

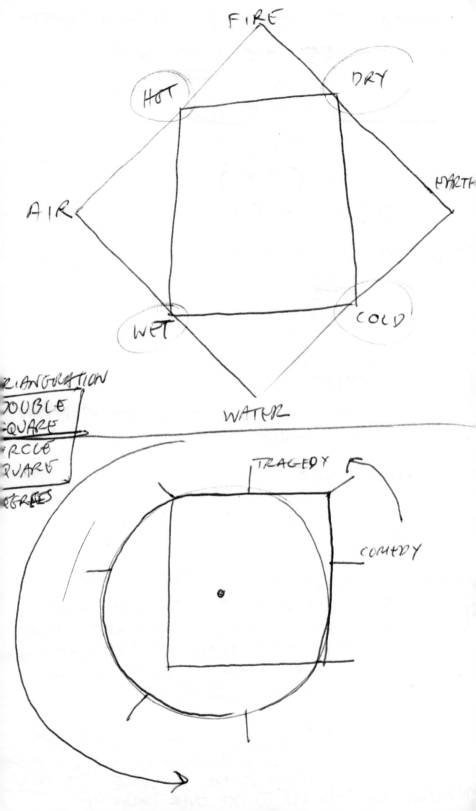

FIRE

DRY

HOT

EARTH

AIR

WET

COLD

WATER

TRIANGURATION
DOUBLE
SQUARE
CIRCLE
SQUARE
DEGREES

TRAGEDY

COMEDY

# PLATONIC SOLIDS →

IN SOLID GEOMETRY ARE CONVEX POLYHEDRON
① W/ ALL OF IT'S FACES BEING REGULAR POLYGONS OF THE SAME SIZE + SHAPE

② THE SAME NUMBER OF FACES MEETING AT EACH OF IT'S VERTICE

## TETRAHEDRON

(3) SIDES
PER FACE

## CUBE

4 SIDES
PER FACE

## OCTAHEDRON

(3) SIDES PER FACE

## DODECAHEDRON

5 SIDES PER FACE

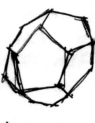

## ICOSAHEDRON

(3) SIDES
PER FACE

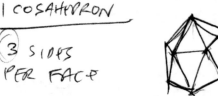

# SEMIOTICS

IS A GENERAL THEORY OF SIGNS
IT IS THE INVESTIGATION OF
- APPREHENSION & UNDERSTANDING OF CONCEPTS.
- PREDICTION
AND - MEANING

# MEANING

STUDIED IN PHILOSOPHY & LINGUISTICS IS
CENTRAL TO THE FIELDS OF - LITERARY THEORY
- CRITICAL THEORY
- EPISTEMOLOGY
- PSYCHOANALYSIS
(SOME BRANCHES)

MEANING IS A DIFFICULT CONCEPT TO PIN DOWN
QUESTIONS ABOUT ~~WHAT~~ HOW SIGNIFIERS & WORDS
MEAN AND WHAT IT MEANS. TO SAY A WORD OR
PHRASE IS MEANINGFUL OR NONSENSE ARE IMPORTANT
TO AN UNDERSTANDING OF LANGUAGE & HUMAN EXPERIENCE
BUT THE ANSWERS ARE ELUSIVE.

## IN LINGUISTICS

THE FIELDS MOST ASSOCIATED W/ MEANING

## SEMANTICS + PRAGMATICS.

DEALS W/ WHAT THE
WORDS OR PHRASES
MEAN

DEALS W/ HOW THE
ENVIRONMENT CHANGES
THE MEANING

SYNTAX + MORPHOLOGY HAVE A PROFOUND
EFFECT ON MEANING. —

## SYNTAX

INFORMATION CONVEYED
EVEN WHEN THE SPECIFIC
WORDS AREN'T KNOWN TO THE
LISTENER.
(MY LISTENING TO GERMAN)
( W/ UNDERSTANDING

## MORPHOLOGY

UNCOVERED MEANING
OF A WORD BY
EXAMINING THE
MORPHEMES/STRUCTURE
THAT MAKES IT UP.

---

### SAUSSURE & STRUCTURALISM

FOR SAUSSURE THE SIGN RESIDES
IN BETWEEN THE SIGNIFIER/SIGNIFIED
RELATIONSHIP. ~~THE SIGN IS NOT MATERIAL,~~
~~IT IS A MENTAL CONSTRUCTION~~

THE SIGNIFIER IS THE SOUND OF THE
WORD            SIGN

THE SIGNIFIED IS THE MENTAL CONSTRUCTION
OR IMAGE ASSOC. W/ THE SOUND.

THE SIGN ESSENTIALLY RESIDES AS THE RELATION
BETWEEN THE TWO. THEY ONLY EXIST IN OPPOSITION
TO OTHER SIGNS. BECAUSE SIGNS ARE ARBITRARY

MEANING CANNOT BE IN THE SIGNIFIER
BECAUSE THEY ARE ARBITRARY.

SO MEANING IS THE SIGN ITSELF. THE SAME
THING. THIS MEANS THAT MEANING IS BOTH
WITHIN US & COMMUNAL. SIGNS MEAN BY REFERENCE
TO OUR INTERNAL LEXICON & GRAMMAR, DESPITE
CONVENTION, SIGNS CAN ONLY MEAN TO THE INDIVIDUAL
MEANINGS VARY FROM INDIVIDUAL TO INDIVIDUAL, THOSE THINGS
STAY WITHIN A BOUNDARY → THIS IS WHAT WE CALL REALITY

ROLAND BARTHES FROM "WORK TO TEXT" 1971 ARGUED ~~THAT~~ THAT WHILE A "WORK" ((A BOOK OR FILM) CONTAINS MEANINGS THAT ~~ARE~~ UNPROBLEMATICALLY TRACEABLE BACK TO THE AUTHOR (THEREFORE CLOSED) A "TEXT" (THE SAME BOOK OR FILM) IS ~~ACTUALLY~~ SOMETHING THAT REMAINS OPEN. THE RESULTING CONCEPT — INTERTEXTUALITY IMPLIES THAT MEANING IS BROUGHT TO A CULTURAL OBJECT BY IT'S AUDIENCE & DOES NOT INTRISICALLY RESIDE IN THE OBJECT.

---

CONTRARY TO MEANING IS THE ~~SCIENTIFIC METHOD~~

IT IS FUNDAMENTAL TO THE FORMATION OF NEW KNOWLEDGE BASED UPON PHYSICAL EVIDENCE SCIENTISTS PROPOSE NEW ASSERTIONS ABOUT THE WORLD IN THE FORM OF THEORIES, OBSERVATIONS, HYPOTHESES & DEDUCTIONS

PREDICTIONS FROM THESE THEORIES ARE TESTED BY EXPERIMENT, IF A PREDICTION IS CORRECT THE THEORY SURVIVES.

ANY THEORY WHICH IS COGENT ENOUGH TO MAKE PREDICTIONS CAN THEN BE TESTED REPRODUCIBLY. VARIFICATION OF THEORY IN DIFF. ~~SCEN~~ SCENARIO'S.
— THIS IS THE UNDERLYING LOGIC OF SCIENTIFIC PRACTICE. A CAUTIOUS WAY OF BUILDING A ~~STRUCTURE~~

ART WORKS WITHIN THIS DYNAMIC IMBUENG OBJECTS W/ PARADOXICAL MEANINGS, SELF CONTRADICTING LOGIC.

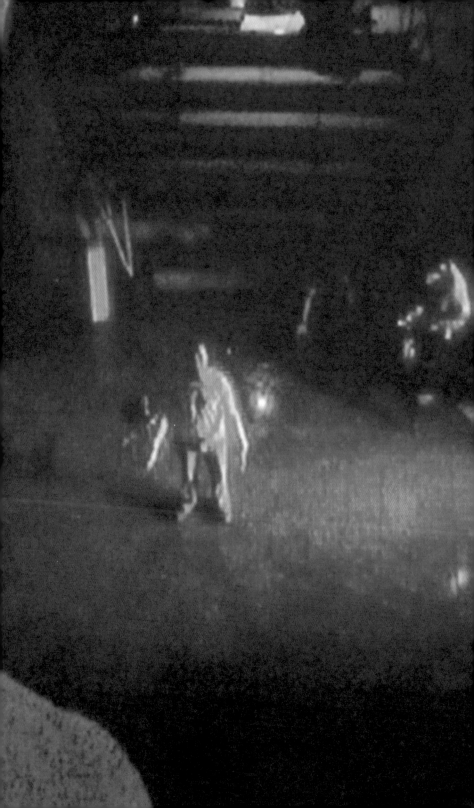

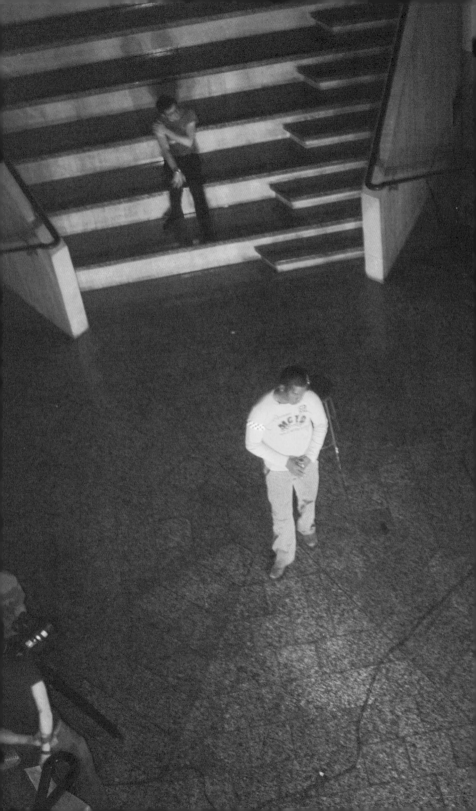

THERE ARE 3 BASIC
AREAS OF CONTROL

1 VISIBILITY W/IN THE COMPOSITION
OF THE SHOT.

2 THE ORDER OF THE SHOTS W/IN THE
CHAIN OF THOUGHTS

3 THE FLOW OF ENERGIES, PHYSICAL
AND EVENTUALLY EMOTIONAL/PSYCHOLOGICAL
ENERGY THROUGH THE WORLD OF FILM.

THIS WILL ALLOW FOR THE CREATION OF SPATIAL
& AFFECTIVE RELATIONSHIPS THAT WOULD ENGAGE
THE AUDIENCES ATTENTION IN THE FLOW OF THE
FILM AND IN THE APPREHENSION OF THE WHOL
FILM AS A "SELF CONTAINED WORLD"

13) MY X-GIRL FRIENDS
BEST FRIENDS

14) BIG FINISH
Goodbye Song

# THINKING IN PICTURES

## DRAMATIC STRUCTURES IN D. W. GRIFFITH'S BIOGRAPH FILMS BY JOYCE E. JESIONOWSKI

THERE IS A KIND OF CONTRACT BETWEEN THE FILMMAKER, WHO CONSTITUTES MEANINGFUL SIGNS AND THE VIEWER, WHO "DECODES" THESE SIGNS IMMEDIATELY DURING THE FILM OR LATER DURING REFLECTION $ HOWEVER, NEITHER THE NATURE OF THE SIGNS NOR THE NATURE OF THIS CONTRA HAS BEEN AGREED UPON. $ 6

THE TRUTH THAT GRIFFITH WISHED TO CONVEY TO HIS AUDIENCE IS AN AMALGAMATION OF MANY CULTURAL AND AESTHETIC ASSUMPTIONS.

ONE HIS MOST DARING ASSUMPTIONS ABOUT THE CINEMA WAS THAT HE COULD MAKE AUDIENCES "SEE THOUGHTS" ON SCREEN! EISENSTEIN CRITICIZED GRIFFITH FOR NOT GOING FAR ENOUGH INTO THINKING FORMS IDEAS - FOR REMAINED STALLED AT THE LEVEL OF PARALLEL MONTAGE.

GRIFFITH MADE NEARLY 500 FILMS IN FIVE YEARS OF WORKING AT AMERICAN MUTOSCOPE & BIOGRAPH CO.!!!

THE VERBAL SILENCE OF THE FILMS OFFERS A OPPORTUNITY TO EXAMINE THE WORKS WITHOUT A WRITTEN OR MUSICAL TEXT OVERLAY. SOMETIMES THE ACTORS WOULD STAND BEHIND THE SCREEN AND RECITE THE LINES.

BUT SETTING THESE ELEMENTS ASIDE, THE BIOGRAPH FILMS REVEAL THE LEVEL OF EXPERIENCE DESCRIBED BY M. MERLEAU-PONTY ( HE HAS RETURNED ONCE AGAIN) IN "FILM & THE NEW PSYCHOLOGY" SAYS: THE PERCEPTION OF FORM, UNDERSTOOD VERY BROADLY AS STRUCTURE, GROUPING OR CONFIGURATION, SHOULD BE CONSIDERED OUR SPONTANEOUS WAY OF SEEING"

HE WANT TO TAP THE SPONTANEOUS & IMMEDIATE ENERGY THAT AN AUDIENCE EXPENDS AS IT'S "NATURAL WAY OF SEEING"

THE UNIQUENESS OF GRIFFITHS APPROACH TO THE CINEMA IS EMBODIED IN THE FORM HE FOUND TO CAPTURE THE "REALISTIC ACTUAL NOW" IN THIS EARLY PERIOD THERE WAS A BASIC AWARENESS OF THE FACT THAT THIS REALISM OF THE "ACTUAL NOW" IN FILM IMAGES WAS A CONSTRUCTED ~~EVENT~~ AND PERCEIVED EVENT. IN 1916 HUGO MUNSTERBERG, A HARVARD PSYCHOLOGIST APPROACHED THE CONSTRUCTION OF FILM IMAGES IN REGARDS TO THE IDEA OF THE PERSISTENCE OF VISION, THE PHENOMENON THAT MAKES CONTINUOUS ACTION FROM A SET OF STILL PICTURES: "THE MOTION WHICH THE VIEWER SEES, APPEARS TO BE TRUE MOTION AND YET IT IS CREATED BY HIS OWN MIND... THE ESSENTIAL CONDITION IS RATHER THE INNER MENTAL ACTIVITY WHICH UNITES THE SEPARATE PHASES OF THE IDEAS OF CONNECTED ACTION"

SCALE & THE LIMITS OF ONE'S CAPACITY

MUNSTERBERG'S OBSERVATION + THEORY PLACES GREAT EMPHASIS ON THE ACTIVITY OF THE VIEWER — THE SENSE THAT THE AUDIENCE PARTICIPATES IN THE CREATION OF THE FILM EVENT ON A FUNDAMENTAL LEVEL

TORMENTOR'S PROJECT

THE ILLUSION OF REALITY CREATED BY PLAUSIBLE CONSTRUCTION TAKES ADVANTAGE OF THE AUDIENCE'S ABILITY TO FILL IN THE GAPS / MISSING DETAILS. MANY FACTORS ARE INVOLVED IN CREATING THE TOTAL "TEXT" OF THE FILM, BUT AUDIENCE PARTICIPATION HAS EVERYTHING TO DO W/ THE NARRATIVE + EMOTIONAL IMPACT OF THE FILM.

GRIFFITH HAD ONLY TO DECIDE WHAT "PLAUSIBLE" MEANT IN TERMS OF FILM "REALITY" + WHAT "GAPS" THE AUDIENCE HAD TO FILL IN TO PARTICIPATE

| | |
|---|---|
| - RESISTANCE | - CLARITY |
| - FACILITATION | - AMBIGUITY |
| - TENSION | - STRONG GRAPHIC ORIENTATION |
| - RESOLUTION | - LACK OF "  "  ,  " |

THE BASIS FOR GRIFFITH'S NARRATIVE EFFECT

EACH SHOT, A SEPARATE ENTITY IS MADE TO CONTRIBUTE TO THE WORLD OF THE FILM "
"LITERARY ABILITY IS NOT ENOUGH... YOU MUST BE ABLE TO VISUALIZE CLEARLY + CONSECUTIVELY... WHEN YOU WRITE SCENE ONE YOU MUST MENTALLY SEE IT REACHING OUT IN UNBROKEN CONTINUITY TO 'FINIS!'".

BIRTH OF A NATION WAS UNSCRIPTED. THIS FILM DEMO'S THATS UNBROKEN CONTINUITY OF THOUGHT + SUGGEST THE EXPERIENCE OF THE WHOLE FILM AS A CHAIN OF INTERACTING SHOTS/THOUGHT. TRANSCENDS EVERY CONSTITUENT ELEMENT OF CONSTRUCTION.

EV KULESHOV (RUSSIAN THEORIST TO LOOK UP)

DESCRIBES "THAT ORGANIZATIONAL MOMENT DURING WHICH THE RELATIONSHIP OF THE PARTS TO THE MATERIALS AND THEIR ORGANIC + SPACIAL CONNECTIONS ARE REVEALED TO THE AUDIENCE" *

BORROWED SUN

MUNSTER DESCRIBED THE EXPERIENCE

WE ARE FAMILIAR WITH THE ILLUSIONS IN WHICH I BELIEVE WE SEE SOMETHING WHICH IS SUPPLIED BY OUR IMAGINATION ... ARE WE NOT ALSO FAMILIAR / THE EXPERIENCE OF SUPPLYING BY OUR FANCY THE ASSOCIATIVE IMAGE OF A MOVEMENT WHEN ONLY THE STARTING POINT + END POINT ARE GIVEN, F A SKILLFUL SUGGESTION INFLUENCES OUR IND? "

V HIS BIOGRAPH FILMS, GRIFFITH AIMED AT CREATING A CONCRETE VISUAL STYLE THAT WAS ASICALLY NARRATIVE IN THRUST.

DRAMA GRADUALLY ASSUMES THE QUALITIES DELIBERATE + REPOSE " ... OF QUIETUDE + EXACTNESS IN A MEDIUM THAT BEGAN IT'S HISTORY W/ XUBERANT + GENERALIZED MOVEMENT.

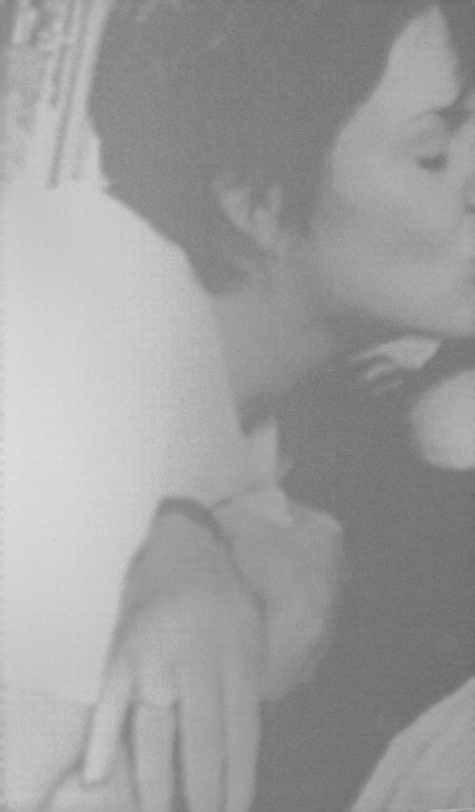

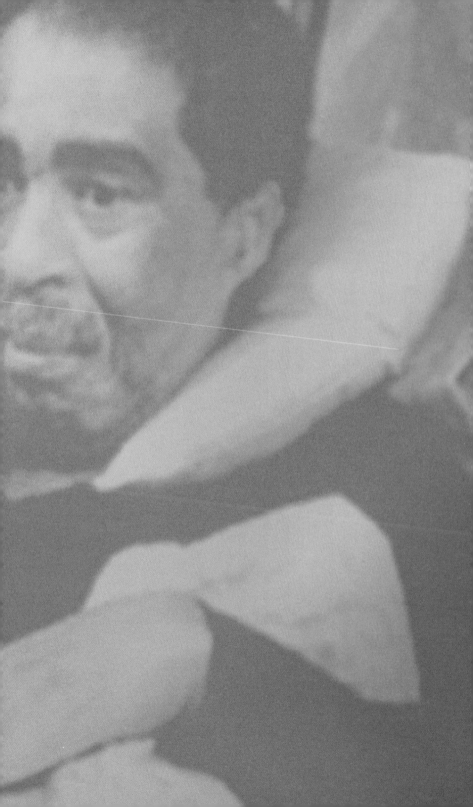

Um...my dad calls. He always calls on holidays that have nothing to do with him. It's Mother's Day, "Oh hello Dad," he wants a new cripple van. He's Mr. Big Stuff, Mr. Big Idea. I'm like, "Dad, what's the cause?" I already bought him a wheelchair, I didn't tell you that? Yeah I already bought him a wheelchair. Yeah, a big fancy electric wheelchair and it has a thing that you attach to the car. And, and, oh by the way, he walks, he walks, YES HE WALKS!

Just, just sometimes he doesn't wanta walk, so he needs that that wheelchair, he wants to motor around, "Unnnnnnngggghhhhhhhh". So apparently, the brand new wheelchair that I bought him, that is not enough, he wants to get the cripple car. So, he said,

# LOOK, UM, GIVE ME $30,000'S THEY GOT A BRAND NEW VAN, YOU DRIVE THAT UH, GIMP, GIMP, GIMP, GIMP CHAIR IN THERE. THE RAMP GOES UP THE DOORS SLAM SHUT, AND I DRIVE AWAY.

And I was like, "Wow, $30,000's?"

"Yeah, $30,000's."

"It's brand new?"

"Brand spank'n new."

"They don't have any used ones?"

"You're not gonna believe this, the used ones cost more then the new ones."

"Really?!? Really!?"

"Yeah, that's what the guy told me."

"Ok, wow! So you mean to tell me, if I got a used one, ..."

"It would cost more. I know it sounds crazy, but that's what he said."

"All right, ummm, wow."

So I'm thinkin' about this and I said the only way I can really gain control of the situation, so I said, "look Dad, look here, I need you to write down everything that you just told me. Send me an email."

He's like, "Well, why do I have to write it down? I just told you."

I know he's getting a little angry there.

"Well, cause I am walking down the street and I wanna, I wanna remember everything... single thing that you told me and I don't want to miss anything and I want to take it to my business manager and talk to his lawyer and then we are gonna get this situated cause we gonna find you this van."

He was like (sound of sucking his teeth), "Yeah, I'll talk to you later."

It's been three days and I still haven't gotten the email.

But it got me thinking... You know my parents divorced when I was 10 years old. And that first Christmas was really...it was a hard Christmas. My dad had come back, after he left the family and I was really upset, I am the youngest of three children and my mother, she told my father when he was at the house that, "you need to talk to your youngest son, cause he's upset." So we got in his rental car and he was driving me around Detroit and, um, I was crying, and I just wanted my parents to be together... I really did. And my father tried to okey-doke me. You know when you a kid and the parents think they gonna do that little kid knowledge, that little Jedi kid knowledge, you know.

So he's like, "Well, David, you know when you're little like when you were like in kindergarten and you had this teacher that you really loved at the beginning of the school year and you said this is the best teacher in the whole world? I hope that I can stay in this class my whole life! That's how I felt with your mom. But then like around Thanksgiving I didn't want to be in that class anymore."

I'm like, who in the fuck is he talking to?

"My mother is not a teacher, she is my mother, you are my father, you have to be there for me...I am a child."

I told him, "You're not being a good father."

He got really angry, pulls the car over and says "I am not gonna sit in this car and be lectured to how to be a father by some 10 year old. Tell me how to be a father!" He said,

# FATHERHOOD IS PURELY BIOLOGICAL. MY JOB IS OVER, I OWE YOU NOTHING.

I thought, I think that he said something important.

I don't know. I was kid I didn't really, I didn't really know, I didn't know the gravity, the weight of those words, and I, and I came home and my mom's waiting in the doorway. I told her what my dad said. She was upset, and um, I often think about that whole thing. And the older I got, the more those words would set and settle in my psyche, and I really came to understand exactly what my father said and what he meant. So I finally did get that email with the list of all his gimpy accessories he wanted on the van, so I wrote him back. And I said, "Dad, I would love to get you a new gimp van, but I can't, because fatherhood is purely biological."

# IMPLICIT KNOWLEDGE -VS- ABSURDITY
## (KNOWN)                    (UNKNOWN)

GETTING
AHEAD

ALZHEIMER
DISEASE

UNTITLED
FATHERHOOD
IS PURELY
BIOLOGICAL

CONTEXTUAL
HUMOR
OR
IMPLICIT
KNOWLEDGE

BURNT UP
AND CRIPPLED

FATHERHOOD IS PURELY B/O
€4?
IS IT SOMETHING I SAID?

HUMOR IN GENERAL & JOKES IN PARTICULAR ALLOWS FOR THE MEETING OF DEVASTATING & INCOMPREHENSIBLE MATTERS (SUBLIME EFFECTS)

DEATH IS INCOMPREHENSIBLE, UN-UNDERSTAND-ABLE AND CANNOT SIZE IT WITHOUT ~~MEASURE~~ (MEASURE) REMAINDER, AND IT CANNOT BE IGNORED.

MANY SUCCESSFUL JOKES INCORPORATE ABSURDITY AND THE HUMAN RESPONSE TO ABSURDITY IS LAUGHTER. (WHY?)

( CHOCOLATE BAR TATTOOED ON MY CHEST )

WHEN WE LAUGH AT A TRUE ABSURDITY, WE SIMULTANEOUSLY CONFESS THAT WE CANNOT MAKE SENSE OF IT AND THAT WE ACCEPT IT. IT EXPRESSES OUR FINITE CAPACITY AND OUR ABILITY TO LIVE W/ WHAT WE CANNOT UNDERSTAND.

INCOMPREHENSIBILITY AND UNREPRESENTABILITY
↓
THEY ARE UNSETTLING

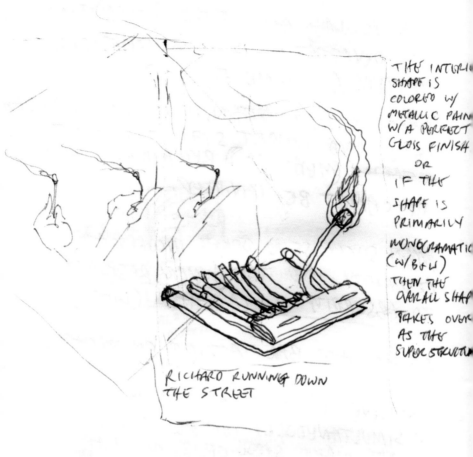

THE INTERIO
SHAPE IS
COLORED W/
METALLIC PAIN
W/ A PERFECT
GLOSS FINISH

OR

IF THE
SHAPE IS
PRIMARILY
MONOCRAMATIC
(W/ B & W)
THEN THE
OVERALL SHAP
TAKES OVER
AS THE
SUPER STRUCTUR

RICHARD RUNNING DOWN
THE STREET

THAT'S THE PROBLEM W/ TIMING AND ART !
THE JOKE'S RESONANATE IT ECHO'S + FADES W/ TIME
THE OBJECT IN IT'S DEFFINITUDE IS UNYIELDING
IN IT PRESENTNESS. PUT IT ALL IN THERE AND LET IT
RIDE ! OH MERCY ...

THE UNREACHABLE POINT
THE AUSGANG
↑

SO WHAT IS THE MIDDLE ?

EVERYTHING IS ROTATING AROUND
A CENTER POINT AND SHOOTING
OUTWARDS.

UNSTABLE FORMS PRODUCING GEOMETRY

CREATION OF LIFE
THROUGH SCIENCE AS

↓

BIOLOGICAL

↑

DISREGARD OF DAVID BY
HIS FATHER

WHAT LINKS THEM AS WELL AS A
RATIONALITY BASED ON REASON
ONE REDUCING FAMILIAL TIES TO
BLOOD AND THE OTHER BLOOD TO
MATHEMATICAL + SCIENTIFIC
REASON. BOTH ARE REDUCTIVE
AND SPEAK OF FATHERHOOD, ~~ONE~~ ALCHEMY
~~OF~~ TAKING UP THE ROLE OF GOD, THE
OTHER OF ~~ABANDONMENT~~ + BREAK DOWN OF PATERNAL

"LIFE IS CONTROLLED."

~~NO ONE KNOWS~~

NOBODY'S PAIN IS LIKE OURS, BUT THE
MOON'S DARK SIDE DRAWS THE TIDES.

> THE LEGENDARY PARKER BROTHER
> SAYING HIS FIRST WORDS
> IN 12 YEARS.

IT MAKES ME CRY, THIS REALIZATION
SEEMS SO PROFOUND TO ME, AND I AM
UNCERTAIN AS TO WHY. I AM STRUCK BY
HOW DEEPLY I FEEL TOUCHED... THE PAIN...
I CAN'T REALLY PUT THINGS INTO WORDS
RIGHT NOW. IT IS A PARTICULAR EXPRESSION
THAT I WOULD NOT HAVE FELT UNTIL NOW

OLE.

FATHERHOOD IS PURELY BIOLOGICAL,

IS IT SOMETHING I SAID?

THE WORK SHOULD HAVE A LOGIC OF IT'S
OWN, BE SELF PERPETUAL IN IT'S REASONING
ASSORTED — SORTED — IRREGULAR —

(1) FATHERHOOD
IS PURELY
BIOLOGICAL

FATHERHOOD
IS PURELY
BIOLOGICAL

FATHERHOOD
IS PURELY
BIOLOGICAL

(3) FATHERHOOD
IS PURELY
BIOLOGICAL

FATHERHOOD
IS PURELY
BIOLOGICAL

FATHERHOOD
IS PURELY
BIOLOGICAL

FATHERHOOD
IS PURELY
BIOLOGICAL

(4) IS PURELY
BIOLOGICAL

FATHERHOOD
IS PURELY
BIOLOGICAL

(2) FATHERHOOD
IS PURELY
BIOLOGICAL

FATHERHOOD
IS PURELY
BIOLOGICAL

FATHERHOOD
IS PURELY
BIOLOGICAL

FATHERHOOD
IS PURELY
BIOLOGICAL

FATHERHOOD
IS PURELY
BIOLOGICAL

FATHERHOOD
IS PURELY
BIOLOGICAL

FATHERHOOD
IS PURELY
BIOLOGICAL

FATHERHOOD
IS
PURELY
BIOLOGICAL

FATHERHOOD
IS PURELY
BIOLOGICAL

(5) FATHERHOOD
IS
PURELY
BIOLOGICAL

# CREW

**PERFORMERS** David Alan Grier, Cheryl Lynn Bruce, and Merc Arceneaux, Sr.

**DIRECTOR OF PHOTOGRAPHY** Ron Clark

**2ND CAMERA OPERATOR** Jon Stuyvesant

**STEADY-CAM OPERATOR** Carl Wiedemann

**SOUND ENGINEER** Chad Miner

**PRODUCER** Merc Arceneaux, Jr.

**SHOOT COORDINATORS** Melissa Holbert and Wendy Coffelt

**PRODUCTION PHOTOGRAPHY** Rashid Johnson, Melanie Schiff and Robb Hill

**PRODUCTION ASSISTANTS** Kamilah Autmon, Mercedes Cooper, Colleen Devanie, Mike Flavin, Manol Georgieff, Rebecca Guerra, Jeff Johnson, Ashley Joyce, Doyle LaCrua, Jeff List, Crystal McNeil, Holly Rodricks, Andy Rohr, Thad Sattayatam, Alisha Sheets, Randy Taylor, Alex Zajczenko, and Dan Zox.

**THE BANDS** Pit Er Pat, Dark Fog, and The Pringles

**LOCATIONS** The UIC Science and Engineering Building, Zakopane's Lounge, and the UIC Theater, thanks to Neal McCollam.

**PROGRAMMING AND INSTALLATION ASSISTANCE** Amber Almanza, Tyler Britt, Paul Dickinson, Yasmin El Tigani, Janna Feister, Chris Hammes, Jonathan Kinkley, Ika Knezevic, Scott Lockhard, UIC Assistant Professor Jennifer Reeder, and Philip Von Zweck.

**INSTALLATION PHOTOGRAPHY** Tom Van Eynde

**SCHOOL WORKSHOPS** Thank you to Albizu Campos High School teacher Joe Burton, Westside Alternative High School teacher Joe Bukovitch, artists Gretchen Hasse and Amanda Gutierrez, and Marvin Garcia and Sunshine Deal of the Alternative Schools Network.

# COLOR PLATES